ESSENTIAL GUIDE TO
DRAWING
Perspective
& Composition

ESSENTIAL GUIDE TO

DRAWING

Perspective
& Composition

A PRACTICAL AND INSPIRATIONAL WORKBOOK

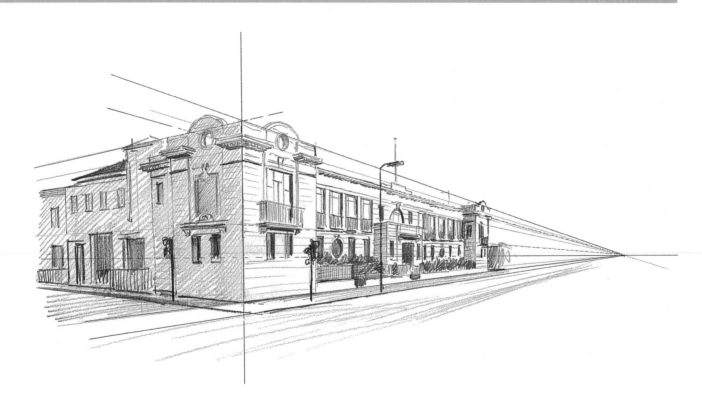

BARRINGTON BARBER

ARCTURUS

ARCTURUS

This edition published in 2019 by Arcturus Publishing Limited
26/27 Bickels Yard, 151–153 Bermondsey Street,
London SE1 3HA.

ISBN: 978-1-78888-895-0
AD002350UK

Printed in China

CONTENTS

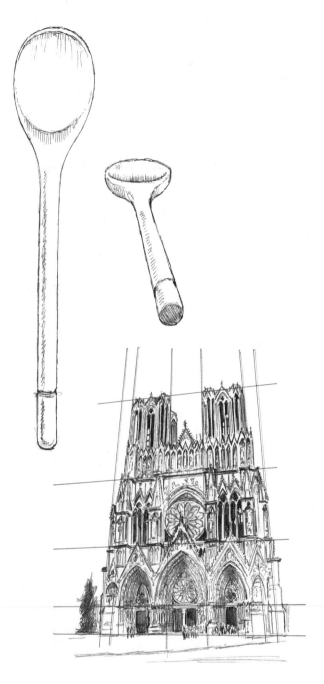

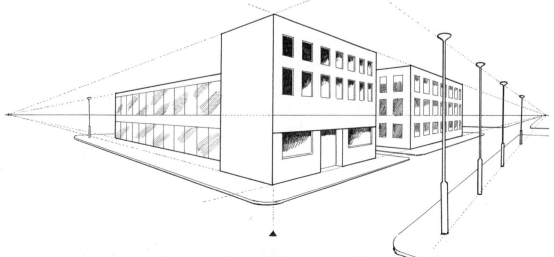

///// Introduction

Using perspective is the technique of making a two-dimensional drawing – with length and breadth – appear to acquire a third dimension – that of depth. Perspective was the great discovery of the Italian Renaissance artists, based upon mathematical principles. The renowned architect and engineer Filippo Brunelleschi was the man generally considered to be the prime tester and discoverer of the laws of perspective. He painted a picture of the Baptistry in Florence according to his own system of horizon lines and vanishing points.

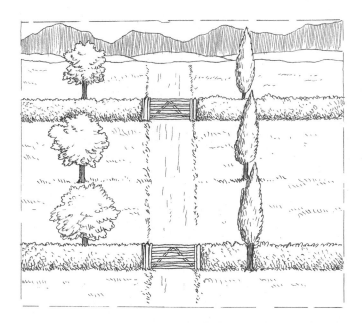

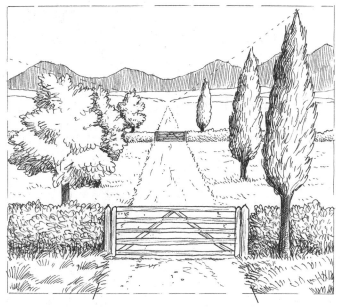

Compare the two pictures shown above, one drawn without much attention to perspective, and the other based on the system of single point perspective.

Note how the trees and gateways are all the same size in the first picture, whether they are close to the viewer or far away. Also, the road stays the same width even as far as the horizon; nor is there much difference between the texture of the nearest trees and hedges and those in the distance. The result is the effect of a rather flat landscape.

The second version shows what happens when you devise a method of interpreting the same

landscape seen in terms of space. The nearest objects are both larger and more textured than those further away, and already this gives a sense of depth to the picture. The road appears to narrow as it recedes into the distance, eventually disappearing to a single point far off on the horizon. Although this is a fairly simple drawing the effect is immediate.

Perspective underpins the composition of most artworks. In this book we will be looking at how you can best employ perspective techniques to make your artworks appear more convincing to the eye.

Any medium is valid for drawing perspective scenes and I have shown a range of possibilities here. You probably don't need to buy all the items listed below and it is wise to experiment gradually. Start with the range of pencils suggested, and when you feel you would like to try something different, do so. For paper, I suggest starting with a medium-weight cartridge paper.

Pencils
HB B 2B 4B

Conté charcoal pencil

White carbon pencil

Graphite pencils

Fine line pen

Fine nib push pen

White chalk

Conté stick

Willow charcoal

Drawing ink

No 5 sable brush

No 2 nylon brush

Scraper-board tool

Clutch pencil with silver wire point

Cone of Vision

When we look at any view, there is a field of vision surrounding us that can be divided into the area where we see things clearly and – at the periphery – another area where we can hardly define anything at all. The overall effect is to create a 'cone' of vision, within which we can see objects clearly, and outside which we are aware of nothing except light and darkness.

In the diagram, a figure is standing at a point in space called the 'station point'. From this point, the figure looks straight ahead at the centre line of vision. The horizon is naturally at eye-level, and where the line of vision cuts across the horizon is the centre point of an area that includes everything you can see of the space in front. The circle of vision is that part of the cone of vision that meets with what is known as the 'picture plane'. This is the area upon which all your images are to be drawn. It is usually perpendicular to the ground plane of the surface on which you stand. The picture plane covers an area containing all that could go into your picture. You might choose to crop down your picture area, but it is possible to draw anything within the focus of this space.

Picture plane

Cone of vision

Eye-level or horizon

Station point

Ground plane

Eye-level

Relationships in the picture plane

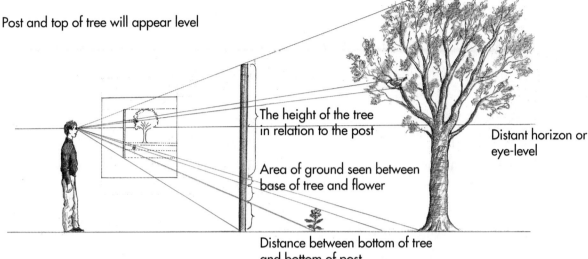

Post and top of tree will appear level

The height of the tree in relation to the post

Distant horizon or eye-level

Area of ground seen between base of tree and flower

Distance between bottom of tree and bottom of post

Here we look at the relationships between the tree, post and flowers and the horizon line. As you can see, the tree in the picture appears shorter than the post, although in reality the post is shorter than the tree. This is the effect of perspective, because the tree is further away than the post. There is also an area of ground between the bottom of the tree and the flower. The horizon line is the same as the eye-level of the viewer.

Using a common unit of measurement

A large subject such as a street scene, in which proportions and perspective have to be taken into account, can be difficult to draw accurately unless you use some system of measurement.

For the urban scene shown here, I chose an element within the scene as my unit of measurement (the lower shuttered window facing out of the drawing) and used it to check the proportions of each area in the composition. As you can see, the tall part of the building facing us is about six times the height of the window. The width of the whole building is twice the height of the window in its taller part and additionally six times the height of the window in its lower, one-storey part near the edge of the picture.

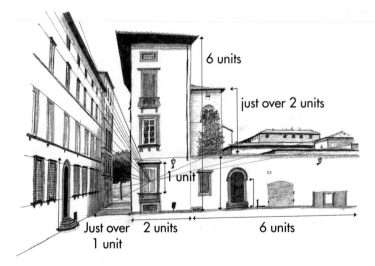

6 units

just over 2 units

1 unit

Just over 1 unit

2 units

6 units

Simple Perspective

The rules of perspective are fairly simple, but there are many ways of contrasting the lines of perspective to give the right effect. Drawing from observation will help you to see how perspective works in reality. Here we look at various devices that help to explain the theory.

Rule number one of perspective is that objects of the same real size look smaller the further away they are from the viewer. Therefore a man of 6ft (1.8m) who is standing about 6 feet away from you will appear to be about half his real height. If he is standing about 15 feet (4.6m) away, he will appear to be about 8 inches (20cm) tall. Stand him one hundred yards (90m) away and he can be hidden behind the top joint of your thumb, and so on.

The first diagram (above right) gives some idea of how to construct this effect in the picture plane. The posts apparently become smaller and thinner as they approach the point where they would vanish over the horizon, known as the 'vanishing point'. The space between the posts also appears to get smaller. This image gives a good idea of what happens in the eye of the viewer, and you can see how it may be used to create apparent depth on the flat surface of the paper.

In the diagram below, the size of the constructed cube is inferred by the height above eye-level, which makes it appear to be the size of a small house. The dotted lines show the far side of the cube, invisible to the eye (unless the cube is made of glass). It is noticeable that not all the lines are parallel to one another, but follow the rules of perspective and take the lines to the two vanishing points. This device is very convincing to the eye.

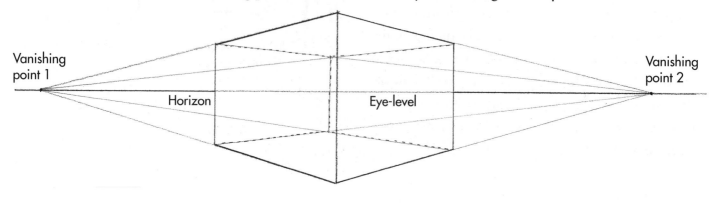

Next look at this diagram of a kitchen as it might be drawn by a designer to show how a range of units will look when built. As in the first diagram opposite, it depends on one vanishing point at the eye or horizon level. Any lines not joined to the vanishing point are either horizontal or vertical.

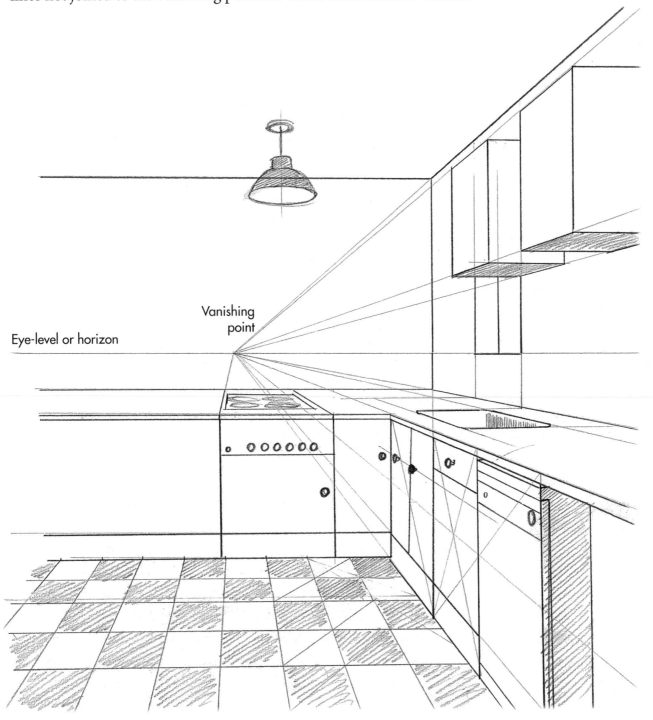

Vanishing
point

Eye-level or horizon

//// One-point Perspective

When you create a picture based on one-point perspective, everything in the picture is dependent on the central point of your vision. All the forms you draw will be connected to this point – the vanishing point.

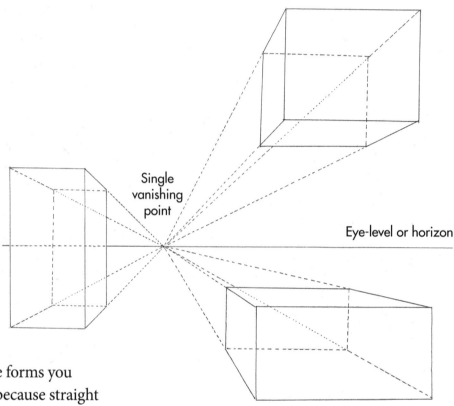

Single vanishing point

Eye-level or horizon

To construct these forms you will need a ruler, because straight lines are essential. Create an image that has a single point on the eye-level or horizon to which all lines of depth will be related.

Draw a horizon from one side of the paper to the other and place a point in the centre of it. Then construct three rectangles in the space of the picture, one entirely above the horizon, one entirely below it, and one partly above and partly below.

With a ruler, trace straight lines from each corner of the three rectangles to join at the centre point on the horizon.

Having done this, you can now go ahead and construct cubes from your rectangles by drawing a smaller rectangle further along the lines that join the vanishing point, to make a three-dimensional cuboid. In the cube above the horizon, you will see the side and underside and the cube appears to be floating in the air. In the cube below the

horizon you get a similar effect, except the upper surface and side are visible but the underside is not and the cube appears to be resting on the ground. The third cuboid is similar to a building viewed at eye-level because, apart from the front, the only visible part is the side and it looks as though it is towering over your head. This, of course, is an illusion, but it is a very effective one.

Imagine yourself in the empty room visualized in the diagram below, which is based on the perspective lines you've just established. Here there's a low eye-level, which means that you're sitting down; the room has a door to your left and two windows to your right. It has bare floorboards and strip lighting on the ceiling. There's a picture frame hanging on the far wall. Notice how the vertical line indicates your viewing position and the horizontal line shows your eye-level. All the floorboards seem to slope towards the centre point, known as the vanishing point. The lines of the skirting boards and the cornice rail on the walls to each side also slope towards this centre point, as do the tops and bottoms of the door and the windows. In other words, apart from the vertical or horizontal lines, all lines slope towards the centre point – which is why this system is called one-point perspective.

This diagram gives a good idea of how you can set about constructing a room that appears to have depth and space. Now try standing or sitting in a room in your home and see if you can envisage where imaginary horizontal and vertical lines representing your eye-level and viewing position cross. This is the vanishing point for the perspective, to which all lines that aren't vertical or horizontal will slope.

The drawing on the right shows the vast interior of a medieval church. It demonstrates how one-point perspective works, even with an unusual building like this. I've purposely omitted to include furniture in the drawing so that you can see where the perspective lines of the roof, windows and columns meet at one point.

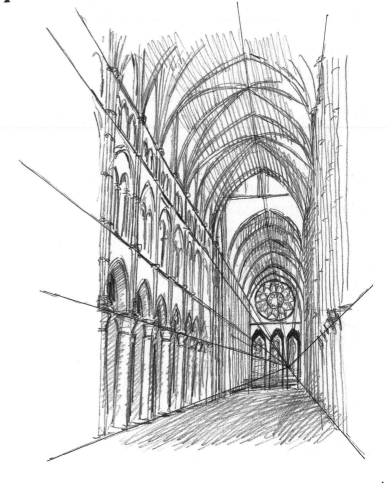

Two-point Perspective

To take this three-dimensional illusion one step further, you need to add another vanishing point to the horizon so that, this time, there is one at each end of the line, making two-point perspective.

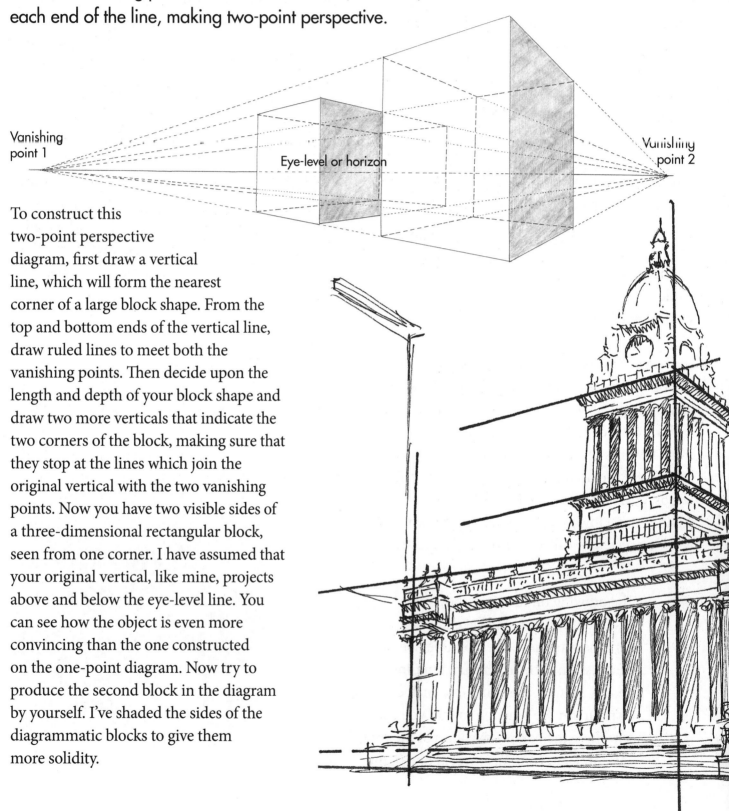

Vanishing point 1

Eye-level or horizon

Vanishing point 2

To construct this two-point perspective diagram, first draw a vertical line, which will form the nearest corner of a large block shape. From the top and bottom ends of the vertical line, draw ruled lines to meet both the vanishing points. Then decide upon the length and depth of your block shape and draw two more verticals that indicate the two corners of the block, making sure that they stop at the lines which join the original vertical with the two vanishing points. Now you have two visible sides of a three-dimensional rectangular block, seen from one corner. I have assumed that your original vertical, like mine, projects above and below the eye-level line. You can see how the object is even more convincing than the one constructed on the one-point diagram. Now try to produce the second block in the diagram by yourself. I've shaded the sides of the diagrammatic blocks to give them more solidity.

In the two-point perspective drawing below, notice how the lamp-posts appear to become smaller as they recede from your point of view. The tops and bottoms of the posts are in line, and the rooflines of the buildings can be joined in straight lines to one of the vanishing points. The same applies to the windows, doorways and pavements. The corner of the nearest building is on the viewing vertical and all the other parts of the buildings appear to diminish as they recede from this point.

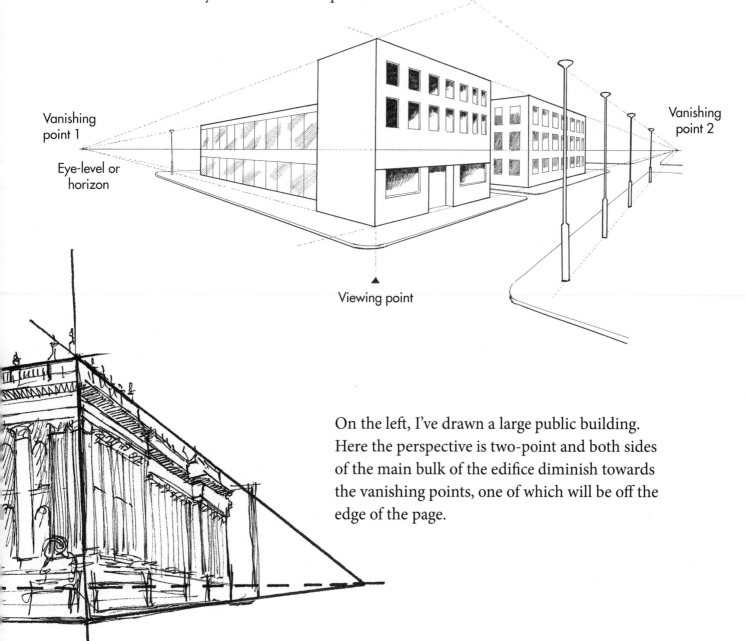

Vanishing point 1

Eye-level or horizon

Vanishing point 2

Viewing point

On the left, I've drawn a large public building. Here the perspective is two-point and both sides of the main bulk of the edifice diminish towards the vanishing points, one of which will be off the edge of the page.

///// Three-point Perspective

Three-point perspective is seldom used, but I have demonstrated it here as it helps to explain how perspective works. It applies to drawings of very tall buildings. It is difficult to visualize three-point perspective in real life unless you are standing at the foot of such a building.

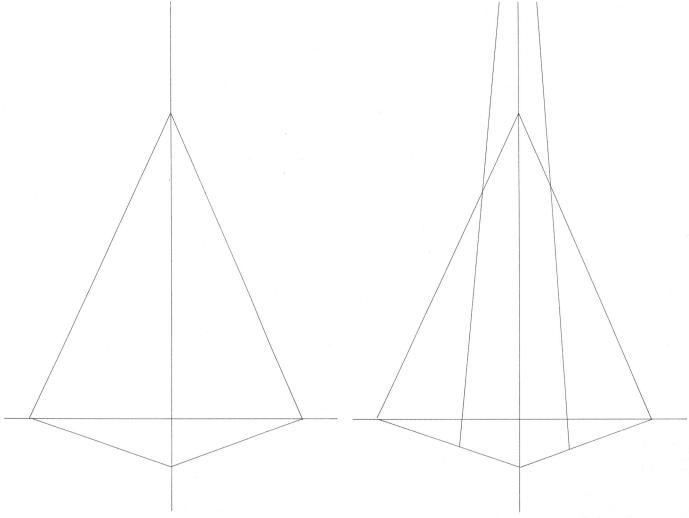

First, as before, draw a horizon line across the paper. After fixing two vanishing points to the left and right, join them to a long vertical line drawn in the centre, as on page 14. In this instance, the top of the vertical should be as high as you can get on the paper, while the lower point should be close to the eye-level line. This, as you can see, creates a very tall quadrilateral.

Now draw two lines either side of the central vertical so that they incline equally at the top, as if you had a third vertical vanishing point somewhere high above the horizon – so high above, in fact, that you would need an enormous sheet of paper to accommodate it.

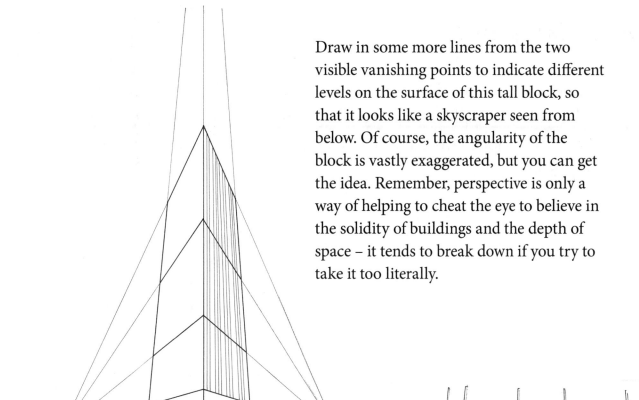

Draw in some more lines from the two visible vanishing points to indicate different levels on the surface of this tall block, so that it looks like a skyscraper seen from below. Of course, the angularity of the block is vastly exaggerated, but you can get the idea. Remember, perspective is only a way of helping to cheat the eye to believe in the solidity of buildings and the depth of space – it tends to break down if you try to take it too literally.

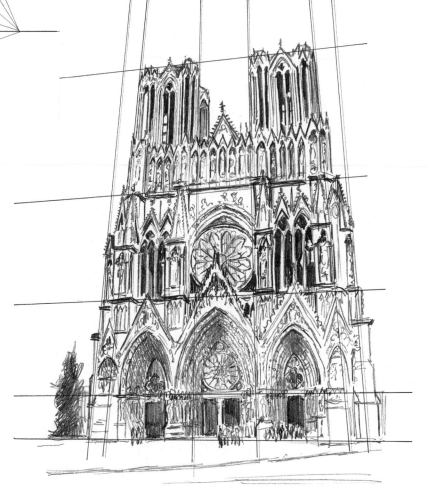

This drawing of the enormous cathedral at Reims in France is a case for three-point perspective. The building's great height, and the fact that the viewpoint is so close, means a third vanishing point is needed high in the sky above the cathedral. All the vertically sloping lines along the sides of the building must eventually meet at a point somewhere above the sheet of paper.

///// Perspective Diagrams

This purely diagrammatic exercise gives you practice in drawing perspective, so that eventually you will be able to apply it without all the construction lines because your mind has absorbed its principles. The co-ordination of the eye and mind is melded by repetition and practice.

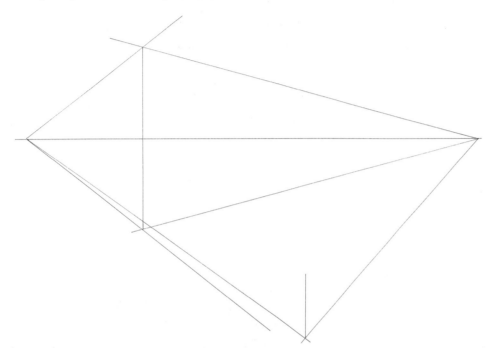

1. Draw the horizon line and vanishing points for two-point perspective as before. This time, draw a vertical towards the left of the page, and a smaller one down near the bottom, as shown. Then join the top and bottom of the larger vertical to the vanishing points; join only the lower end of the smaller vertical.

2. Now draw two more verticals for the larger cube and join them and the top end of the smaller vertical to the vanishing points. Then draw two ellipses up past the higher end of the smaller block.

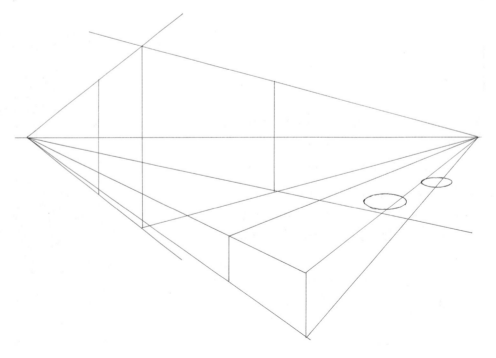

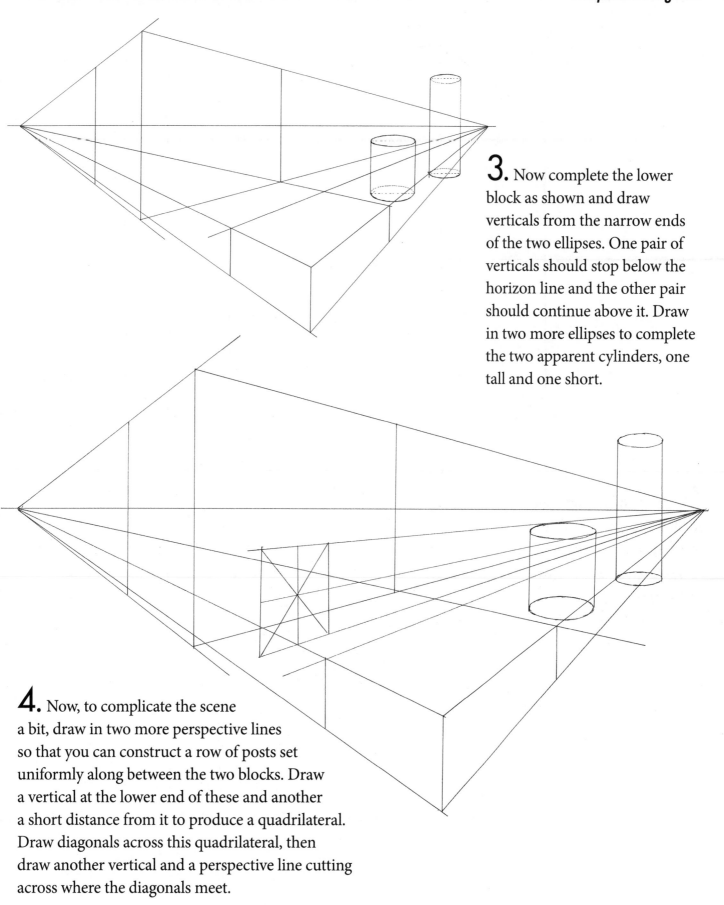

3. Now complete the lower block as shown and draw verticals from the narrow ends of the two ellipses. One pair of verticals should stop below the horizon line and the other pair should continue above it. Draw in two more ellipses to complete the two apparent cylinders, one tall and one short.

4. Now, to complicate the scene a bit, draw in two more perspective lines so that you can construct a row of posts set uniformly along between the two blocks. Draw a vertical at the lower end of these and another a short distance from it to produce a quadrilateral. Draw diagonals across this quadrilateral, then draw another vertical and a perspective line cutting across where the diagonals meet.

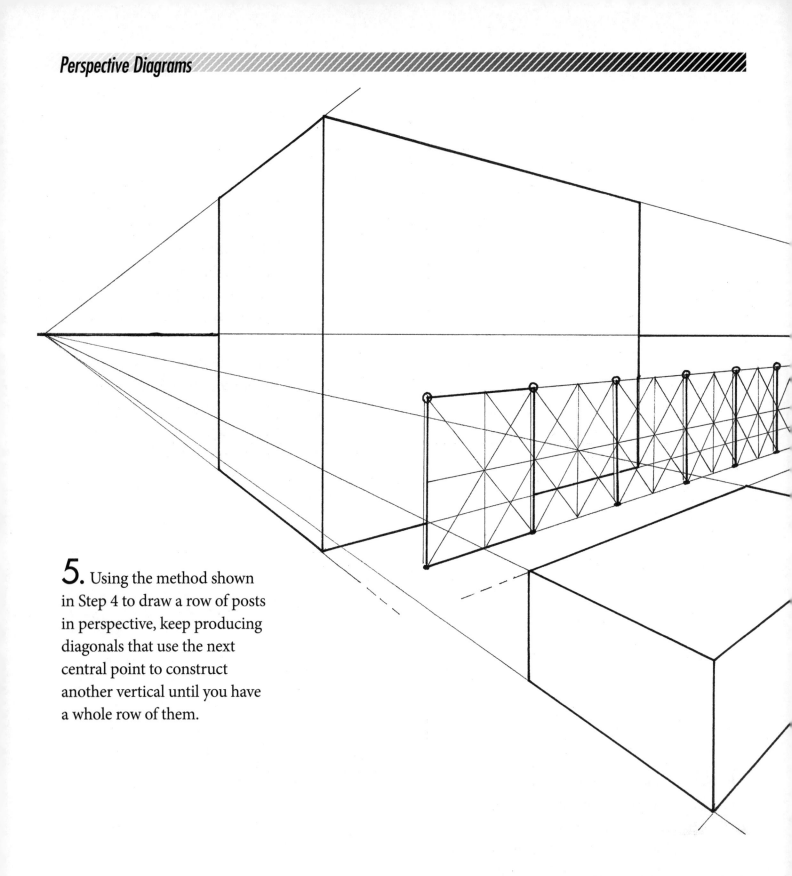

5. Using the method shown in Step 4 to draw a row of posts in perspective, keep producing diagonals that use the next central point to construct another vertical until you have a whole row of them.

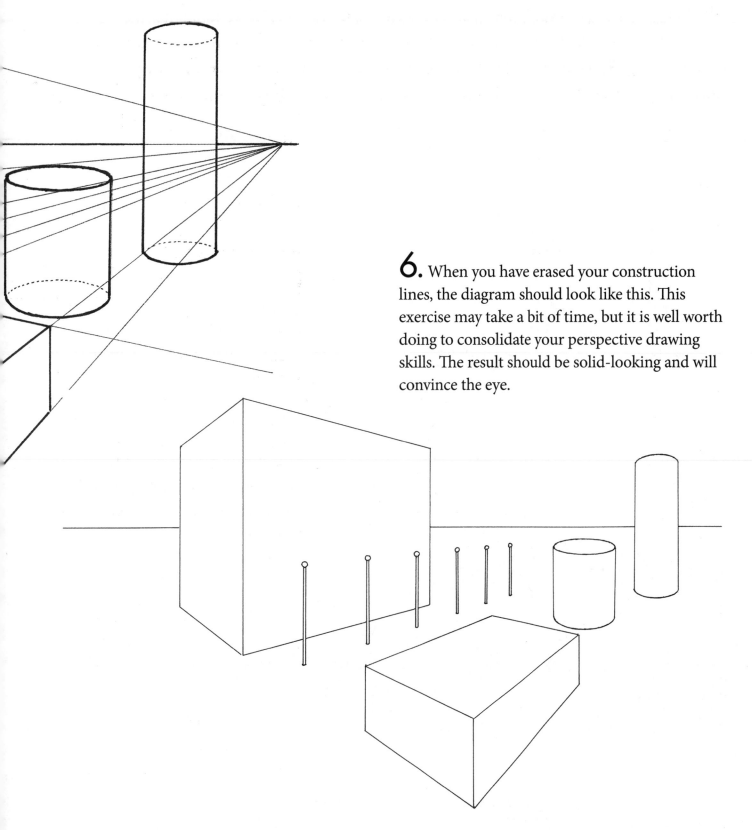

6. When you have erased your construction lines, the diagram should look like this. This exercise may take a bit of time, but it is well worth doing to consolidate your perspective drawing skills. The result should be solid-looking and will convince the eye.

Buildings in Perspective

These examples will help you to become familiar with constructing different views of buildings in perspective. When you are drawing on site, the important lines to identify are the eye-level or horizon line and the lines along the top and bottom edges of the building. Remember that unless you are drawing a building from far away the converging perspective lines will meet at a point somewhere beyond your paper.

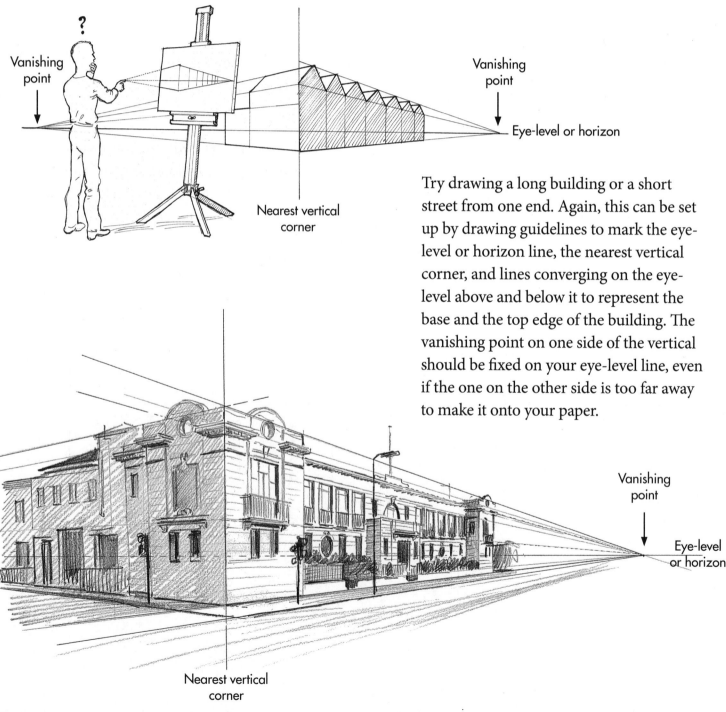

Try drawing a long building or a short street from one end. Again, this can be set up by drawing guidelines to mark the eye-level or horizon line, the nearest vertical corner, and lines converging on the eye-level above and below it to represent the base and the top edge of the building. The vanishing point on one side of the vertical should be fixed on your eye-level line, even if the one on the other side is too far away to make it onto your paper.

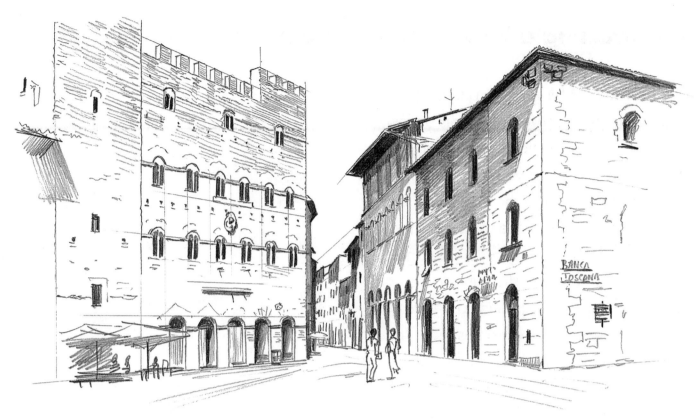

Here one building is set at an angle from the main street. This means that although the same horizon line will be used for all the buildings in the drawing, the vanishing point for this particular building will be much further to the right on the horizon. The vanishing point of the main part of the street is just behind one of the doors on the right-hand side of the oblique building.

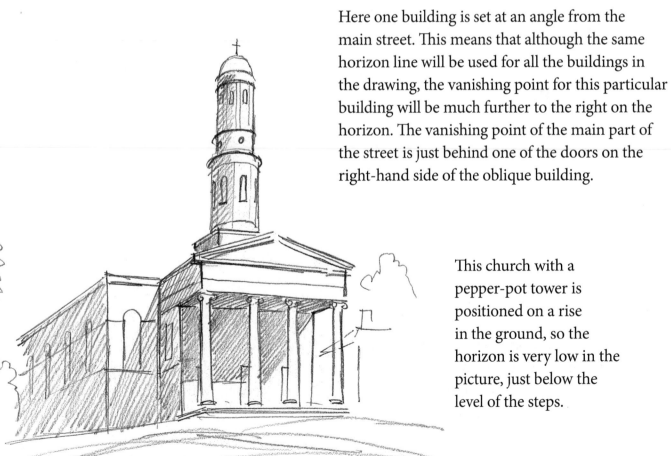

This church with a pepper-pot tower is positioned on a rise in the ground, so the horizon is very low in the picture, just below the level of the steps.

Constructing a View Along a Street

The best subject for gaining plenty of practice in perspective drawing is a view along a corridor or street, particularly if the street is narrow. If you set yourself up to draw looking down the street, you will notice that the lines of the roofs and bases of the buildings converge in the distance. Not only that, but any structure on the surface of the buildings, such as ledges, door frames or window frames, does the same. If you can draw the angle of the convergence of these lines with sufficient accuracy, the street will appear to recede into the depth of the picture.

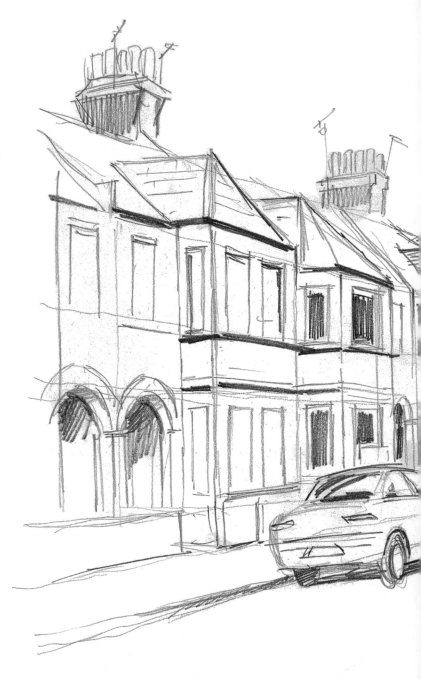

Drawing architecture involves hours of intense investigation in pursuit of an impression that looks something like the view in front of you. It is good practice to try taking a photograph of the view and comparing it with your drawing. You will find that the photograph is not necessarily more correct than the drawing, because the perspective in a photograph is always slightly exaggerated. Nevertheless, the comparison of the two can show how the perspective works. The correct perspective will probably be somewhere between your drawing and the photograph.

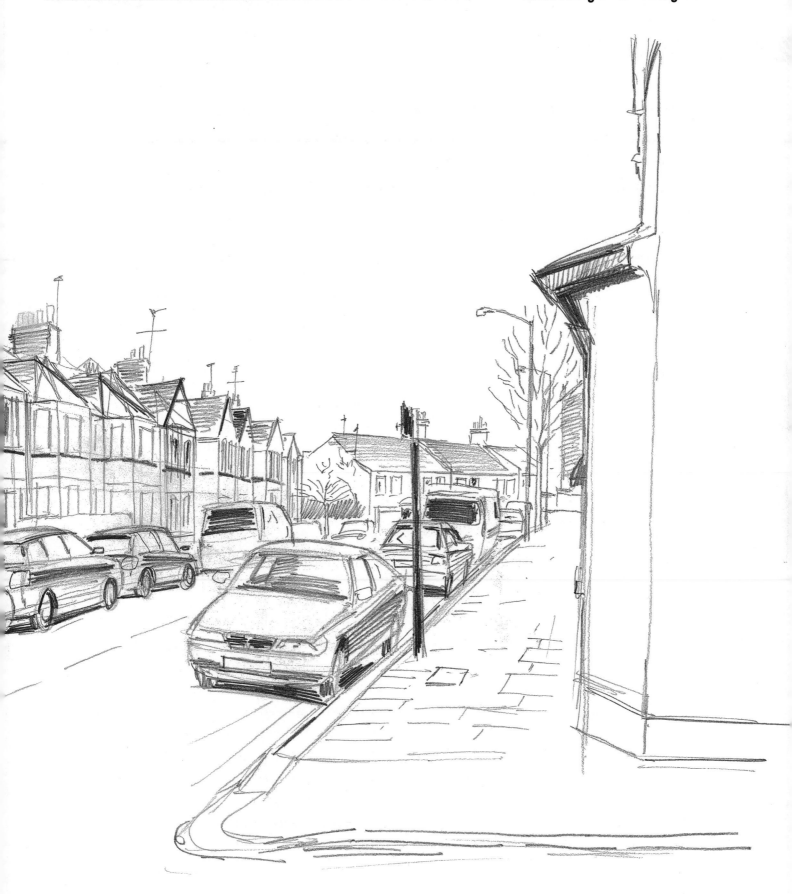

An Urban Scene

Using the techniques of perspective that you've learned, try drawing a more complex urban scene. By now you should broadly understand how to construct a drawing of architectural forms and be able to produce a convincing picture. However, if you're not satisfied with the end result, don't be discouraged – everything will slot into place as long as you keep practising the basics.

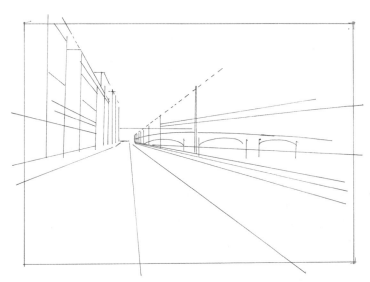

This is essentially a perspective exercise, but approached in an artistic rather than a scientific way. Your eyes will give you all the information you need to draw accurately, but your perspective studies will help your mind to make more sense of it and ease the process of drawing. Choose a location that is easy for you to draw and check on the weather before you start, so that rain and wind don't make things more difficult for you.

Here is an outline drawing of a street by the Arno river in Florence, Italy. In order to show the perspective clearly, I have omitted drawing human figures or cars.

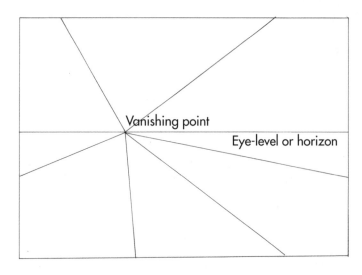

Now look at this diagram of the perspective lines that underlie the original drawing. It consists merely of the horizon line and the main lines that join at the vanishing point. These should inform your own drawing, even if you don't actually put them all in with a ruler. So your task is to find a street scene and, if it looks too complex, simplify it by leaving out any street furniture and buildings that confuse you. Draw from life, at the scene, bearing in mind what you now know about perspective construction.

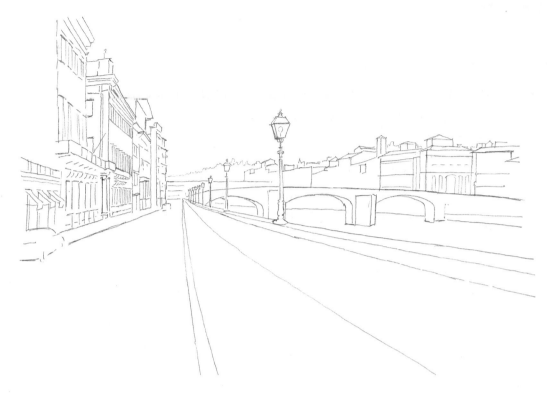

Put in the main shapes first and the details later, when you are sure that the major blocks of the scene are reasonably convincing.

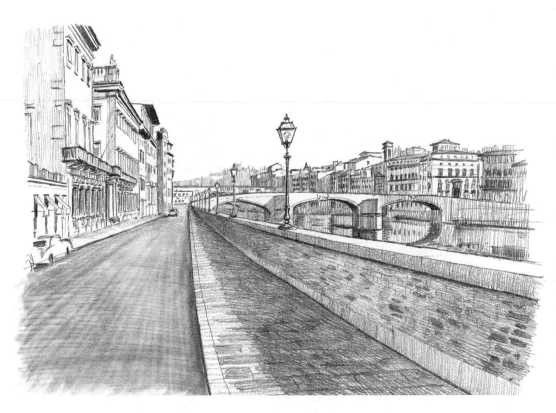

When you have added all the detail you need, put in the tonal areas, using textures to differentiate the various surfaces of the scene. I have given the roadway a smoother texture than elsewhere by smudging the pencil marks with a stump. Notice also how the more distant features have less definition than those in the foreground. This helps to convince the eye of the picture's three-dimensional quality.

Irregular Perspective

Now we are going to look at a large piece of architectural work in which the perspective is not entirely regular, in this instance because of the sloping ground and the slightly odd type of fortification. The horizon line is very low, so the line of the top of the arch is at about 60 degrees from vertical. As very few of the lines are horizontal or vertical, such a drawing does not demand that you organize the perspective to perfection. When faced with a view like this it is better to forget perspective and trust that your eye will give you all the information you need.

Here the vast areas of wall and chunky simplified masses of building give a very strong combination of shapes. The handling of the shadows is important too, because they increase the impression of simplicity and monumental size.

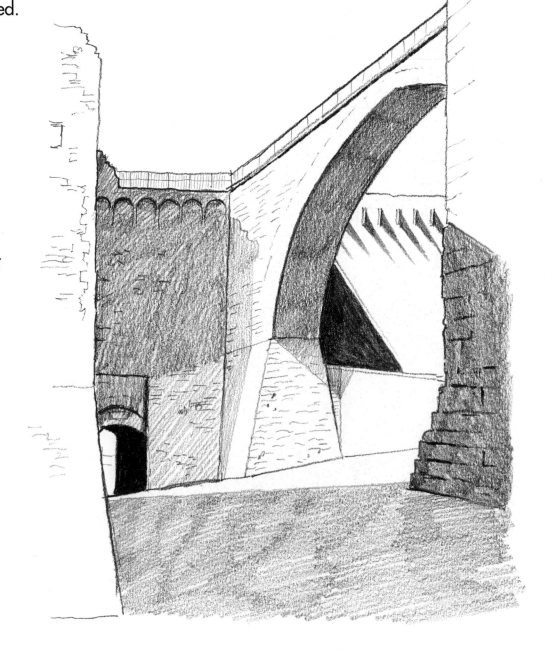

When it comes to drawing rural landscapes, perspective is not so evident as in urban scenes, but it is just as important to show the scene receding into the distance. The effect of atmospheric haze means that objects and landscape features in the distance are not so clear as those in the foreground. This phenomenon is known as aerial perspective.

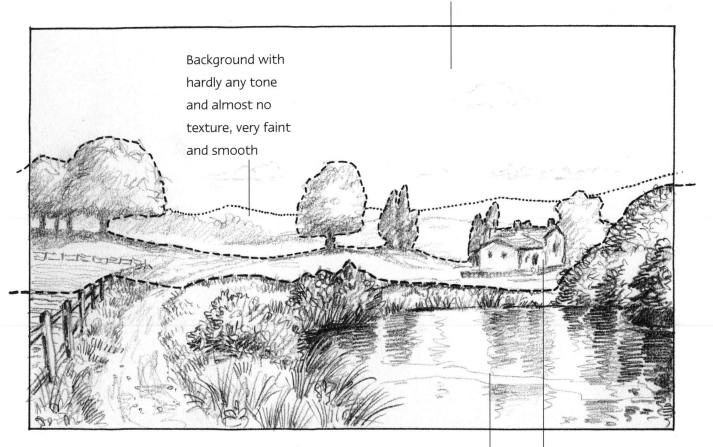

Sky can be considered as part of background

Background with hardly any tone and almost no texture, very faint and smooth

Middle ground with tone and texture, but softer and less intense than the foreground

Foreground with intense tone and contrast and strong textures

In this landscape, the background area is very faint and without detail or much texture – in places it's almost as light as the sky. The middle ground has a little more definition and texture, but still not much detail. The foreground has the greatest definition and the most texture and intensity of detail. This is the effect of aerial perspective.

Compositions by Master Artists

A good way to start understanding the composition of pictures is to look at the work of the masters. Here and over the next few pages we consider the way works have been composed, using perspective to dramatize or underpin their construction. Now you have the basic principles, your best plan for developing your compositional skills is to copy good works of art from books and prints or in local public art galleries.

This example is a picture of Pegwell Bay in Kent by William Dyce (1806–64). Here the composition is a very simple halfway horizon with a range of chalk cliffs jutting into it. All the action in the picture is in the lower half, with various areas of rock and sand on which people are gathering shells and so forth. Most of the significant action is in the immediate foreground. The ladies in their crinolines make pleasing, large simple shapes.

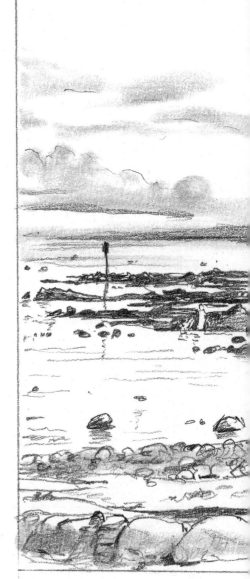

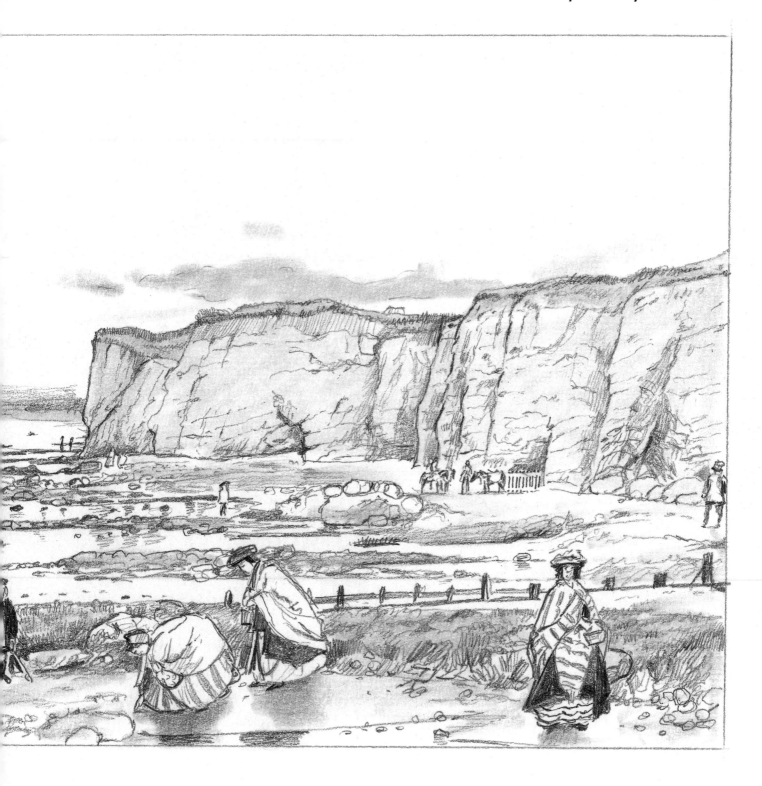

The next example is of a townscape by Walter Sickert (1860–1942). This is defined by the perspective of the street winding away on the left and the foreground shopfront at the right-hand edge. Thus, two perspective depths work to the left and right of the picture.

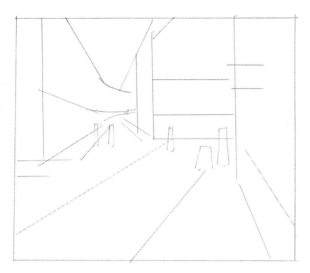

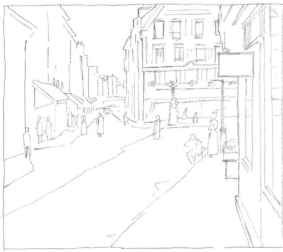

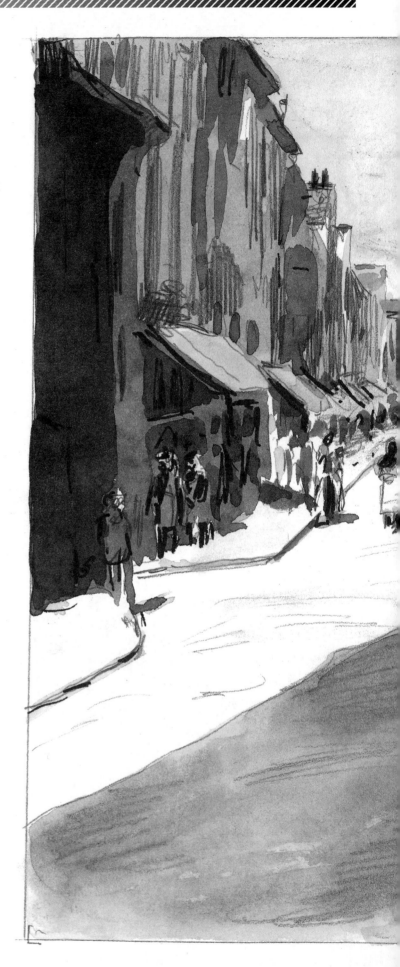

When you come to look at the tonal values, you can see how the dark shadow of the buildings to the right divides the big open space of the foreground street diagonally. It all helps to draw the eye into the centre of the picture and then on down into the far street on the left.

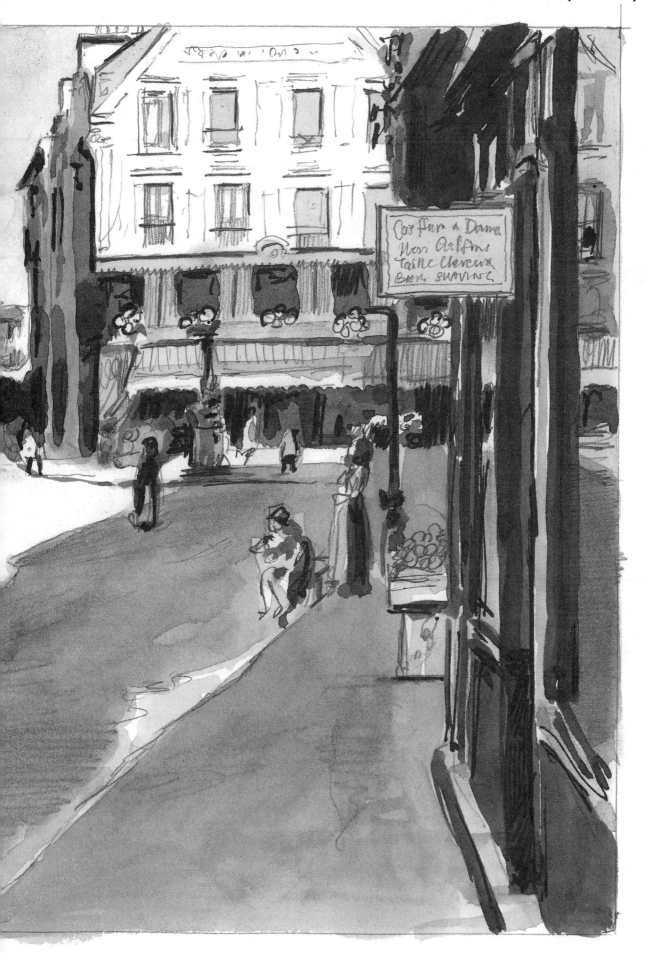

Next, a work by Richard Wilson (1714–82) of the summit of Cader Idris, Wales. This is mainly a large triangle, broken by the curve of a lake and the sweep of more mountain to one side. The curve is repeated twice in a mound below the lake and in another body of water lower down to the left.

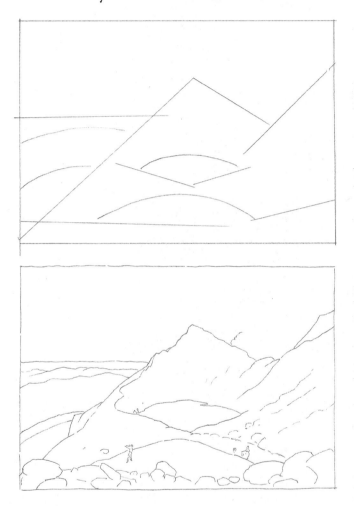

Because of the dramatic view, the tones are important as they show the sharp triangle of the peak above the lake, silhouetted against the sky. You can see the aerial perspective at work as the foreground features show more detail and definition than the hills receding into the distance on the left-hand side of the composition. If you have time, have a go at copying this scene.

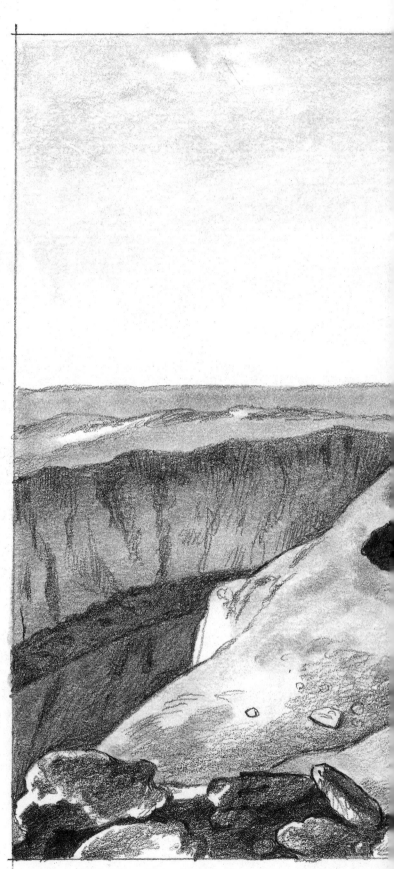

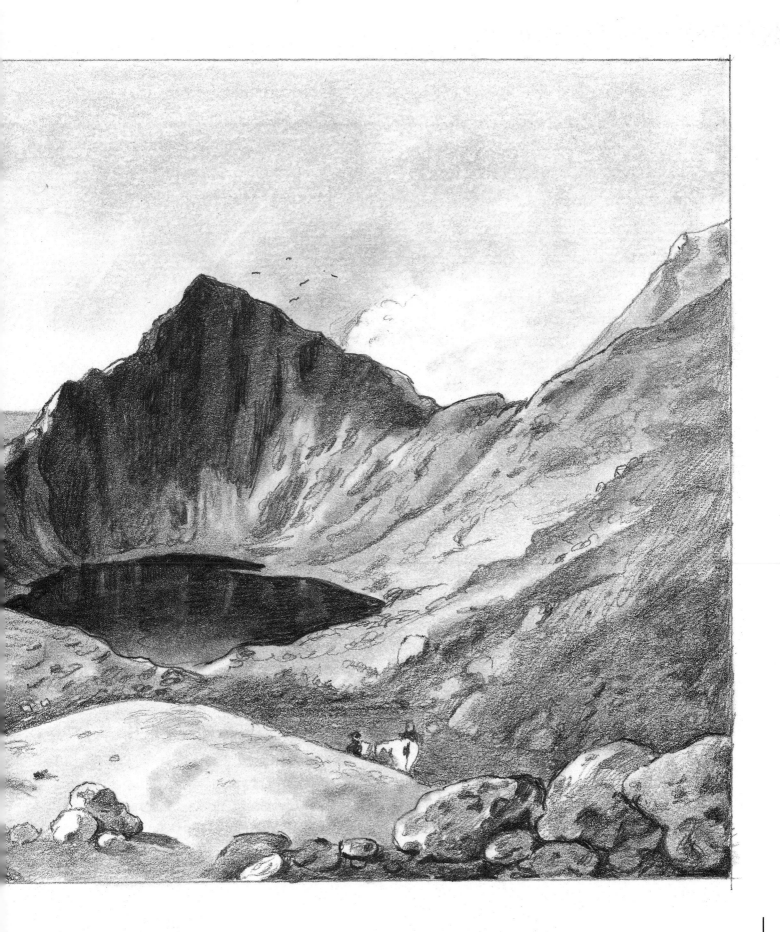

Objects in Perspective

Now that you have been introduced to the theory of perspective and the way in which it relates to the composition of architecture and landscape space, the next thing to do is to look at its effect on the drawing of objects and people. This is generally referred to as 'foreshortening'. First, we shall examine the relevance of perspective to the drawing of everyday objects; I have selected a knife, fork and spoon to begin with.

Start by drawing the knife straight on, so to speak, tracing round it as carefully as you can. You will probably have to make adjustments here and there, as the outline of a three-dimensional object made in this way is always a little out of proportion, especially in terms of thickness.

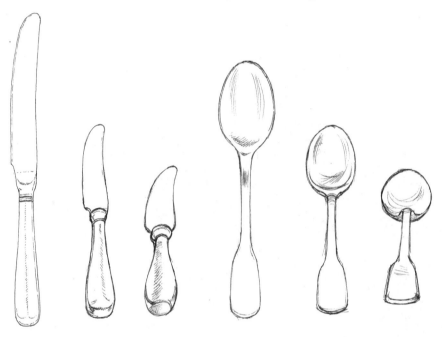

Having produced a fairly accurate drawing with regard to size and shape, place the knife on a surface that lies at an oblique angle from your point of view, thereby giving it some perspective.

As shown in example 2, above, your new drawing will be decidedly different in proportion; it will be shorter than the original outline, although similar in width.

Once more, lay the knife on a surface, this time choosing a position nearer to your own eye-level. You will become aware that, in order to represent precisely what you see on this occasion, you must draw the shape much shorter in length but just as wide. The end of the handle nearest to you will be wider still (see example 3).

Take a look at the three knife drawings and note the proportional differences between them.

Perform the same exercise with the spoon, noting that it will require a slightly different treatment owing to the curvature of the handle. Trace the spoon so that you have an accurate outline of its length and shape.

Position it at an oblique angle from your viewpoint and draw what you can see. It will be shorter than the first drawing but of a similar width.

Draw the spoon lying upon a surface closer to your own eye-level, and notice the foreshortening and the altered contours of the bowl. Each time you will notice that the part of the utensil closest to you appears wider in proportion to its remaining length.

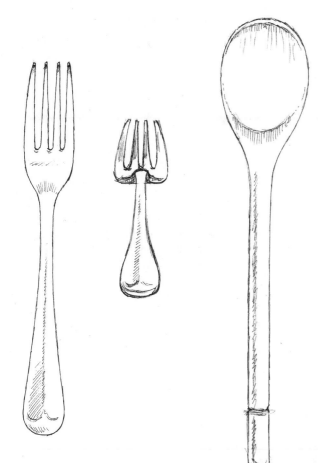

Do a similar exercise with a fork – this time two views will be enough. Then try it with a wooden spoon which, with a flatter bowl, is a much simpler shape to draw than a metal one. Notice how the handle of the spoon gets gradually wider towards the eye.

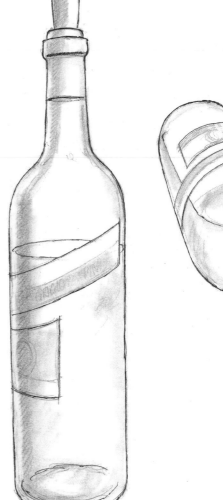

The same exercise can be carried out with something larger, like a bottle of wine. Draw round the shape as accurately as you can, making whatever corrections are required. Now turn the bottle so that you are looking at it from one end only, in this case the neck, and you will see immediately how dramatically the proportion of length to width has been altered. Note how the bottle appears to get narrower towards the base; this demonstrates the foreshortening effects of perspective.

Groups of objects

In these simple compositions, it's easy to see how the effect of perspective makes itself felt in the drawing of objects of similar shape and form which are positioned at different distances from us.

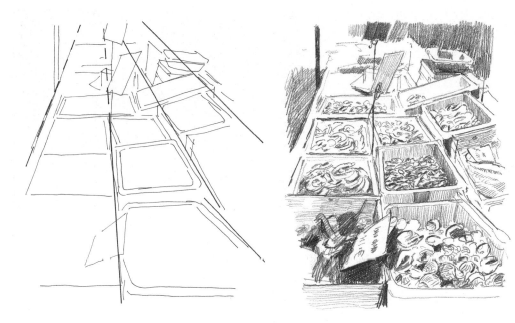

Perspective is used here on boxes of fish and shellfish lined up in a French marketplace.

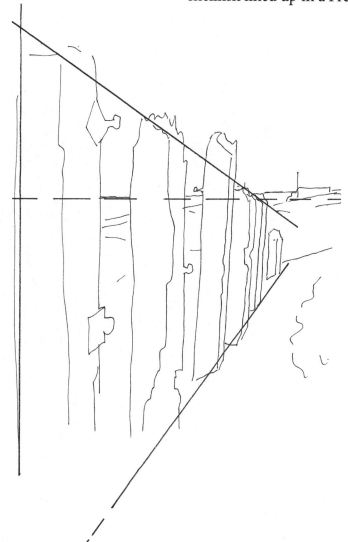

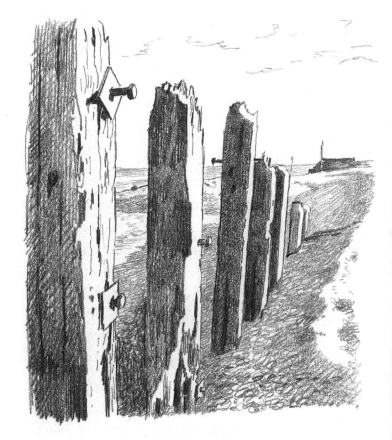

Even in a short row of breakwater posts, the recession from our viewpoint gives a strong sense of depth to the beach scene.

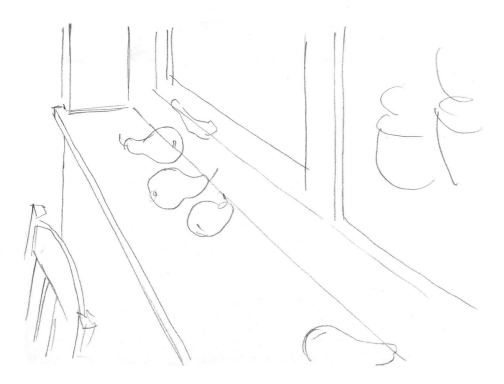

I made these still-life detail drawings during a tour round a room at home. On the windowsill by the door a group of pears was ripening, caught in the shadow cast by the window frame. Because of the strong shadow, they largely melted into the background. Even in such a close-up view, the perspective structure is evident in the angle of the windowsill, sloping away from the viewer.

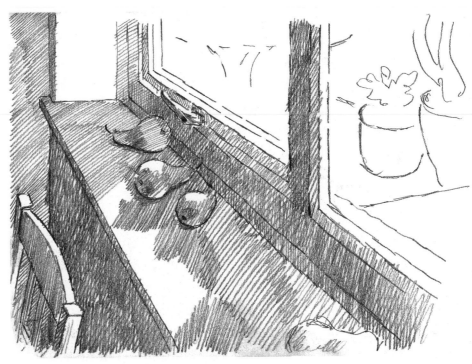

///// Foreshortening the Human Figure

Here, we are concerned with the effects of perspective on the human body when it is seen from an extreme angle. While you may never want to draw someone lying flat in this position, you will often want to draw poses where some parts of the figure are closer to you than others. In all cases, the same rules of perspective apply.

With this exercise, you need to find someone to lie on the ground or on a couch, as flat as possible, preferably on his or her back. You should be seated so that you can see the subject from the feet and then the head, from an eye-level not far above.

When you first try this exercise in drawing, you may find it hard to be convinced by the way the legs or head seem to disappear from view, so that there is hardly any length to them in the drawing.

The figure can look unnaturally distorted if you are unused to considering perspective. Nevertheless, your eyes are very good at seeing accurately; it is only your ideas that make it hard for you to believe what you see. With the male figure, notice how the surface area covered by the legs and feet is larger than the area covered by the torso and head. This is confusing, because we know that if the figure was standing up, these elements would be similar in size.

With the female figure, the head and shoulders seem very big compared to the rest of the body, which recedes from the viewer. This underlines the fact that we perceive objects close to us as larger than those further away. Try bending your arm and looking at your open palm in front of you. Watch the size of your hand apparently grow as you bring it towards your nose.

So, when you start to draw your figure, you may need to draw two lines indicating the way it diminishes as it recedes from your viewing point. My first two sketches give an idea of this.

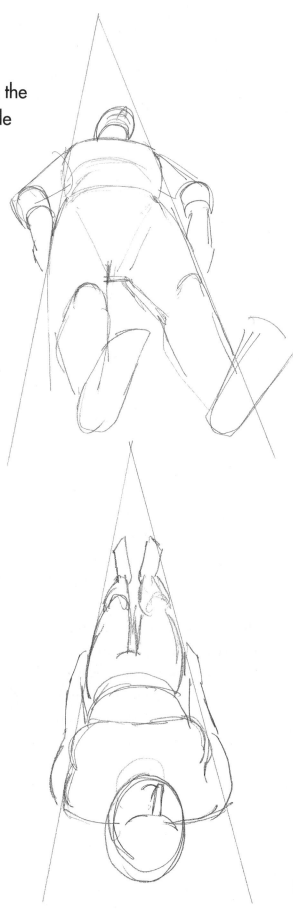

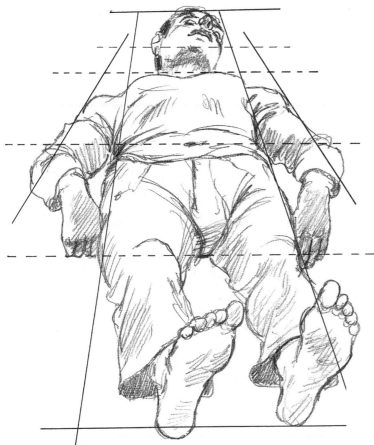

When you have blocked in the main forms quite roughly, start to draw in the larger shapes, remembering to follow carefully what you observe, not what your mind tells you. At this stage, don't be tempted to put in any small detail; simplicity and accuracy are what you are trying to achieve. Once again, measure how the far parts of the body appear in comparison with the nearest parts to ensure that you don't start enlarging the former or diminishing the latter to accord with what you think the human body should look like. Many beginners do this and it takes practice before the message sinks in to the mental processes.

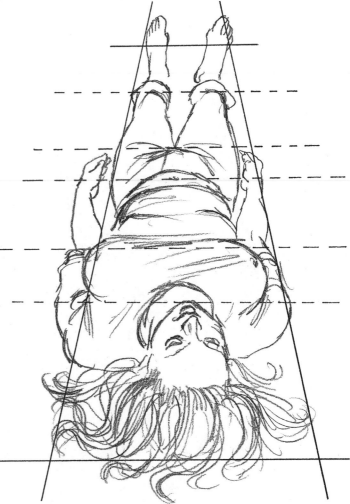

Perspective views: legs

Foreshortening can present one of the most difficult problems when drawing the figure in detail. A specific example might be when a leg or arm is projecting towards your viewpoint. Instead of the expected shape of the limb you get an oddly distorted proportion that the mind often wants to correct. However, if you are going to draw accurately, you have to discount what the mind is telling you and observe directly, measuring if necessary to make sure that these odd proportions are adhered to. In this way, a limb seen from the end on, as here, will carry real conviction with the viewer.

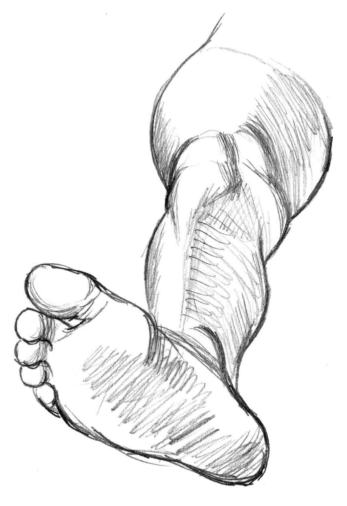

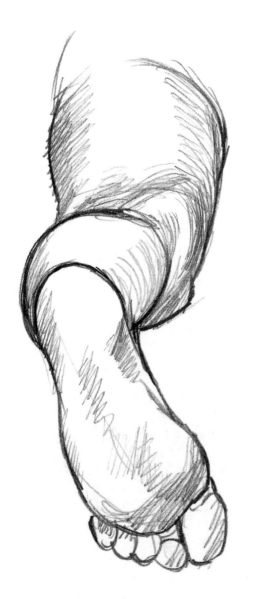

When viewing the leg from the foot end, notice how large the sole of foot looks in comparison with the apparent length of the leg. The muscles and the knee project outwards, their roundness and angularity very pronounced, while their length is reduced to almost nil. If you observe the shapes produced by this view, you shouldn't have any problem. Don't tell yourself that it looks wrong, because it's not; it's just an unusual point of view.

Perspective views: arms

The same situation is evident with the arm as with the leg. In this case the size of the hand will often appear outrageously large, practically obscuring the rest of the arm. Seen from this end-on perspective, the bulge of any muscle or bone structure becomes a much more important feature describing the shape of the arm. Instead of a long, slender shape which we recognize as an 'arm', we see a series of bumps and rounded shapes closely stacked up against one another, so that the length of the arm is minimal and the round section of the arm shape becomes what you see and draw.

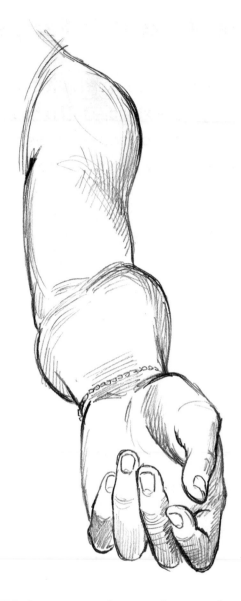

It will help you to make visual sense of a foreshortened hand if you view the limb as though it is one of a group, with the fingers coming off a body (the palm). Take note of the shapes of the tips of the fingers and the knuckles particularly, because these too will be the dominant features of the fingers seen from end-on.

The shape of the fingernail provides another good clue to seeing the finger as it really is. The main part of the hand loses its dominance in this position, but still needs to be observed accurately.

///// Practice: A Scene in Perspective

For the final perspective exercise you only have to look around you at the room you are in to see your next subject. This doesn't mean the task is any easier when you come to draw it, but at least you have now had quite a bit of practice of drawing in perspective, so you will be much more confident of tackling the problem.

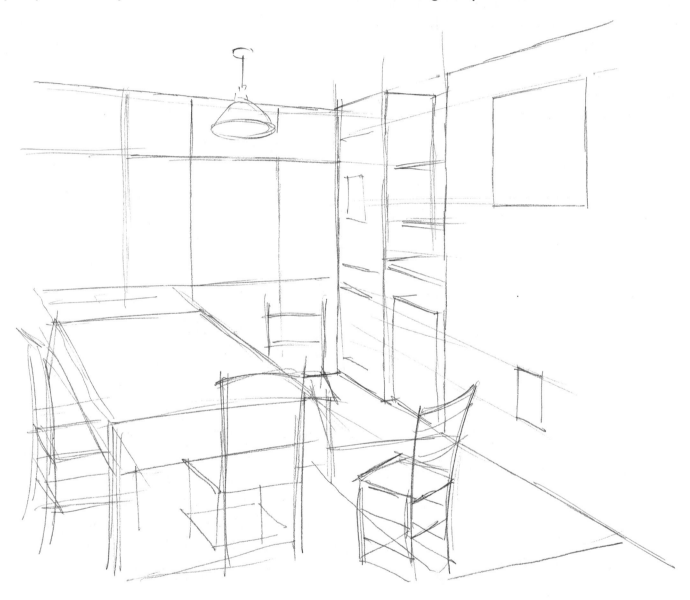

1. First of all, look at this initial sketch of an interior. It will be immediately obvious to you from your studies so far that perspective lines have been used to construct the drawing.

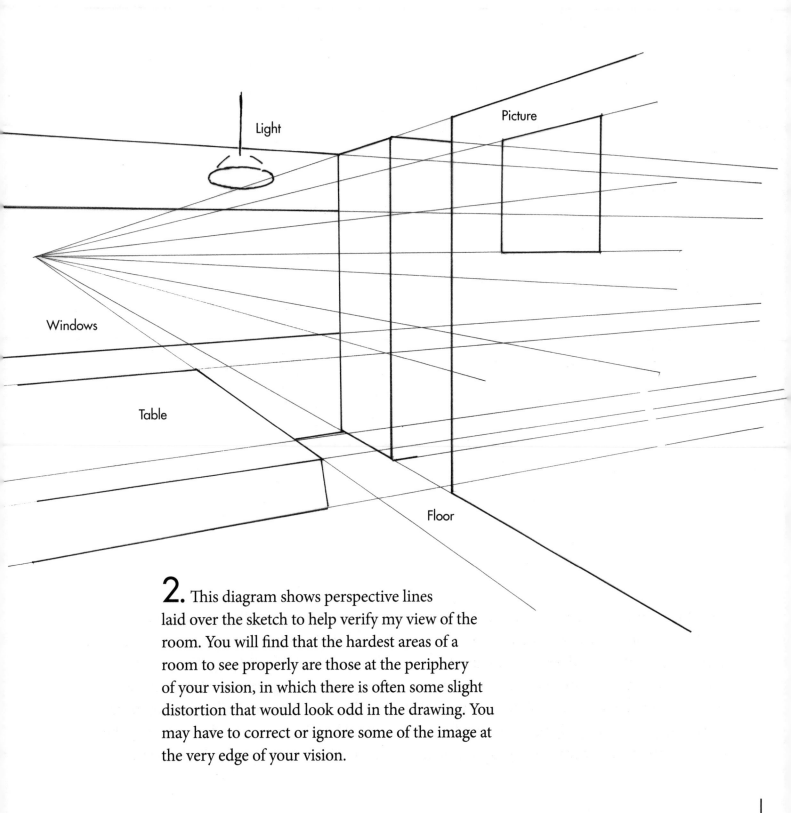

2. This diagram shows perspective lines laid over the sketch to help verify my view of the room. You will find that the hardest areas of a room to see properly are those at the periphery of your vision, in which there is often some slight distortion that would look odd in the drawing. You may have to correct or ignore some of the image at the very edge of your vision.

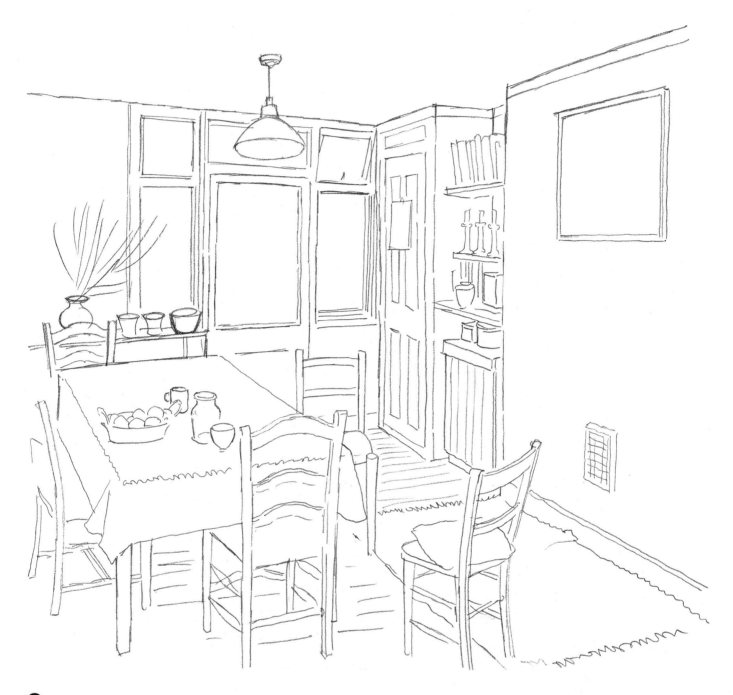

3. Once you've constructed a sketch that you think holds the image correctly, begin to put in the main outlines of the room and furniture within your field of vision. However, if there are any complicated pieces of furniture or objects that make things more difficult, remove them from view or simply leave them out of your drawing.

All artists learn to adjust the scene in front of them to simplify it or make it more interesting and compositionally satisfying. You can see evidence of this in the topographical work of Turner, Canaletto or Guardi, for example. The lines of perspective should enable you to render accurately the proportions of the objects in the scene.

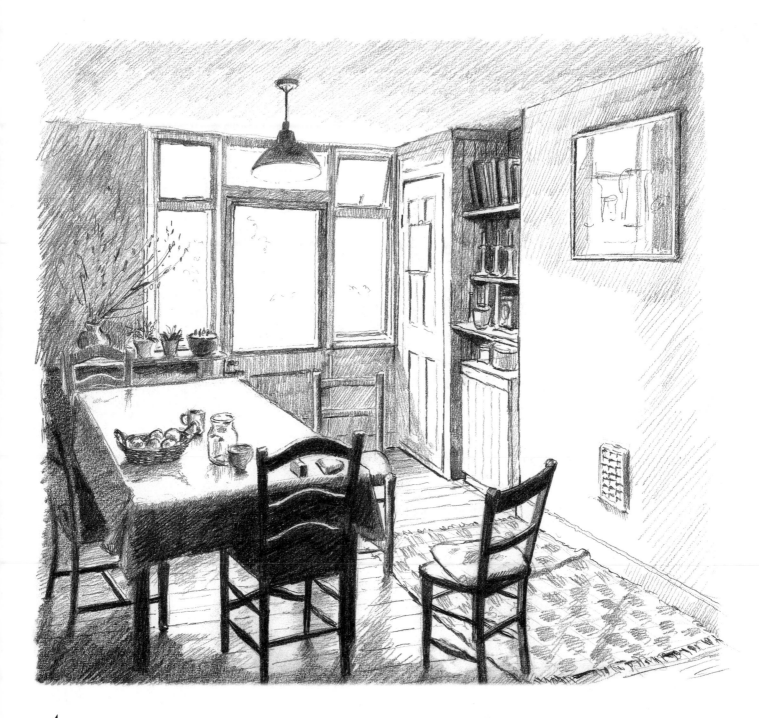

4. You can then work on the tonal values of the scene to give it atmosphere and depth. If you have to leave it and come back later, check that the furniture hasn't been moved and that the angle of light is similar to the time before. If the weather is sunny and you try to resume at a different time of day when it is cloudy you will potentially find the lights and darks very differently placed. The lighting in my scene is partly from the windows and partly from the overhead electric light. Notice how I have built up the tone to a strong black in the chairs nearest to my viewpoint.

///// Index

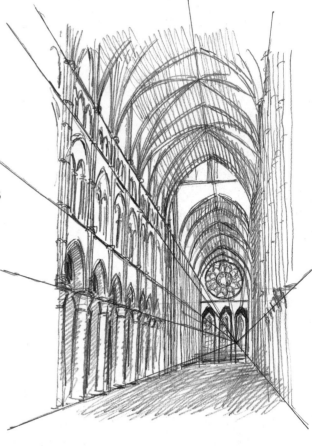

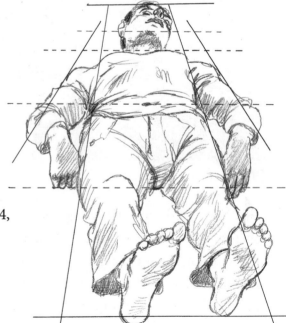